Bev Doolittle
THE FOREST HAS EYES

This book is a special thank you to all the parents, teachers and librarians who have used my paintings to teach children about our Native American heritage and our western wilderness. I hope you find this a treasure to enjoy, share and experience with any child.

As with many of the images in this book, the accompanying print, *No Respect*, makes a playful point of how each species' activities, however great or small, relate to each other. As humans *we* can choose how our actions impact other species and our precious earth.

Bev Doolittle
THE FOREST HAS EYES
by Elise Maclay

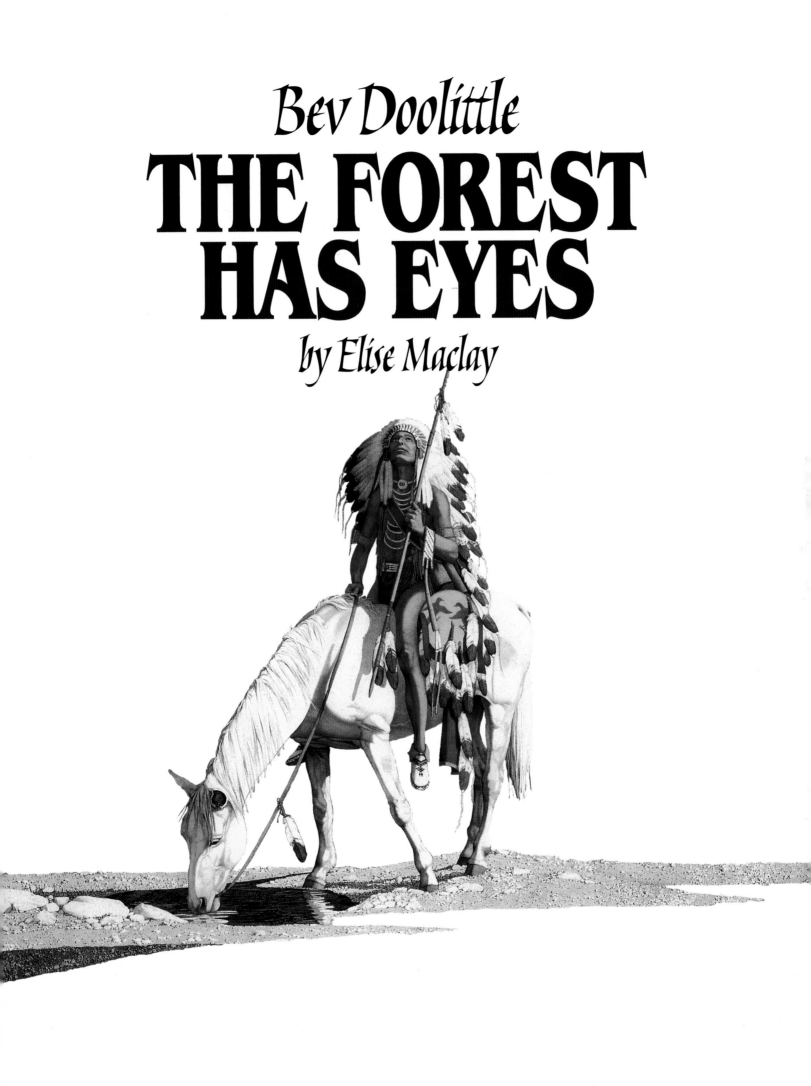

Bev Doolittle
THE FOREST
by Elise Maclay

THE GREENWICH WORKSHOP PRESS

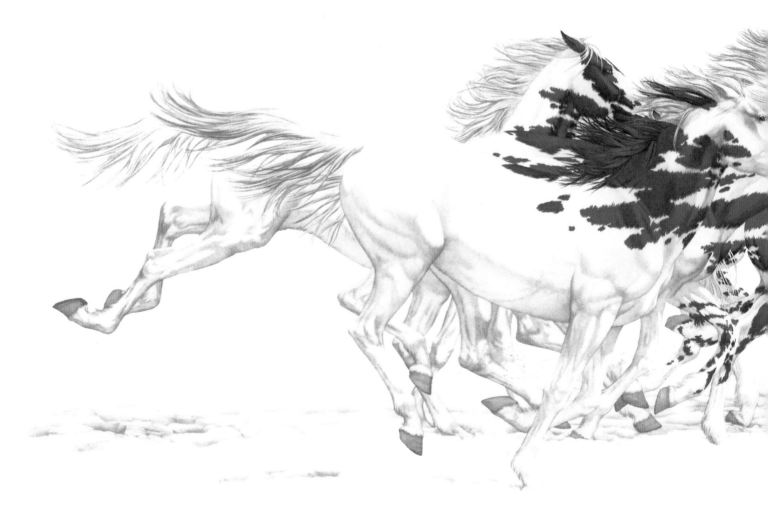

HAS EYES

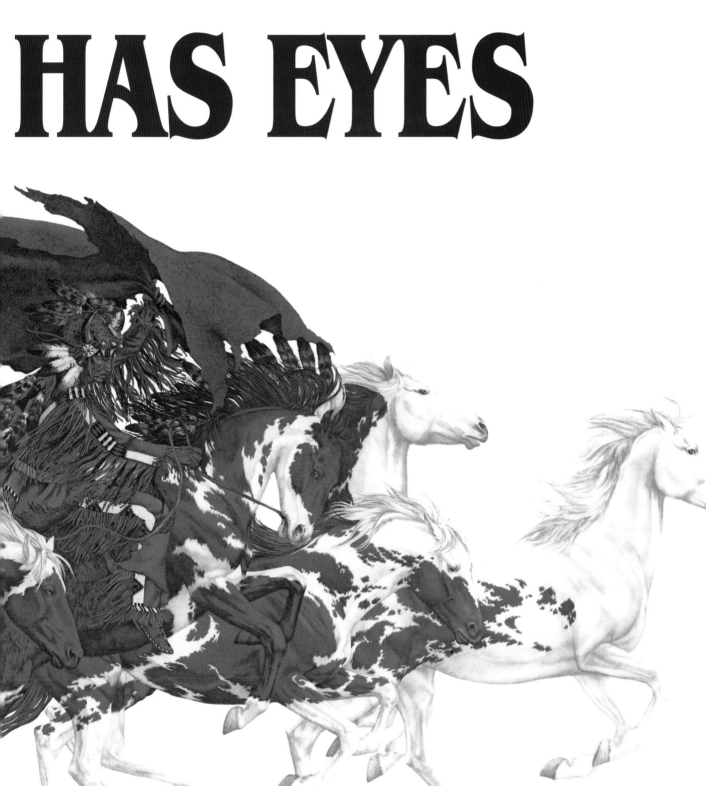

This book is for all children.
May they find the vast number of stories
nature shares with us every day.

A GREENWICH WORKSHOP PRESS BOOK

The Greenwich Workshop, Inc., P.O. Box 875, Shelton, Connecticut 06484-0875.

●

Library of Congress Cataloging-in-Publication Data:
The forest has eyes / Bev Doolittle (paintings) ; by Elise Maclay. p. cm.
Summary: This collection of paintings of the western wilderness and
the accompanying text invite the reader to see the natural world
through the eyes of Native Americans.
ISBN 0-86713-055-5
1. Indians of North America—Juvenile literature. 2. Nature—Juvenile literature.
(1. Indians of North America. 2. Nature.) I. Maclay, Elise. II. Title.
E77.4.D66 1998 970'.00497—dc21 98-7800 CIP AC

●

Other books by Bev Doolittle with Elise Maclay: *The Art of Bev Doolittle* and *New Magic.*
The major works of Bev Doolittle are available as fine art prints published by The Greenwich Workshop, Inc.
For the address of the authorized dealer nearest you, please call 1-800-243-4246.

●

Book design by Judy Turziano
Manufactured in Italy by Amilcare Pizzi
98 99 00 9 8 7 6 5 4 3 2 1

Artists have magic eyes.

They see hidden things,

Things that look like other things.

Things that happened long ago,

Things that might happen tomorrow.

Native Americans have magic eyes.

They see the spirits of animals and trees.

They see that all creatures are related, owl and bear,

Toad and eagle, trout and elk. All have gifts.

All are needed.

You have magic eyes.

You can see things the way artists and Native

Americans see them.

And you can see things your own way, too.

It takes time, but it's exciting and it's fun.

Like making a friend.

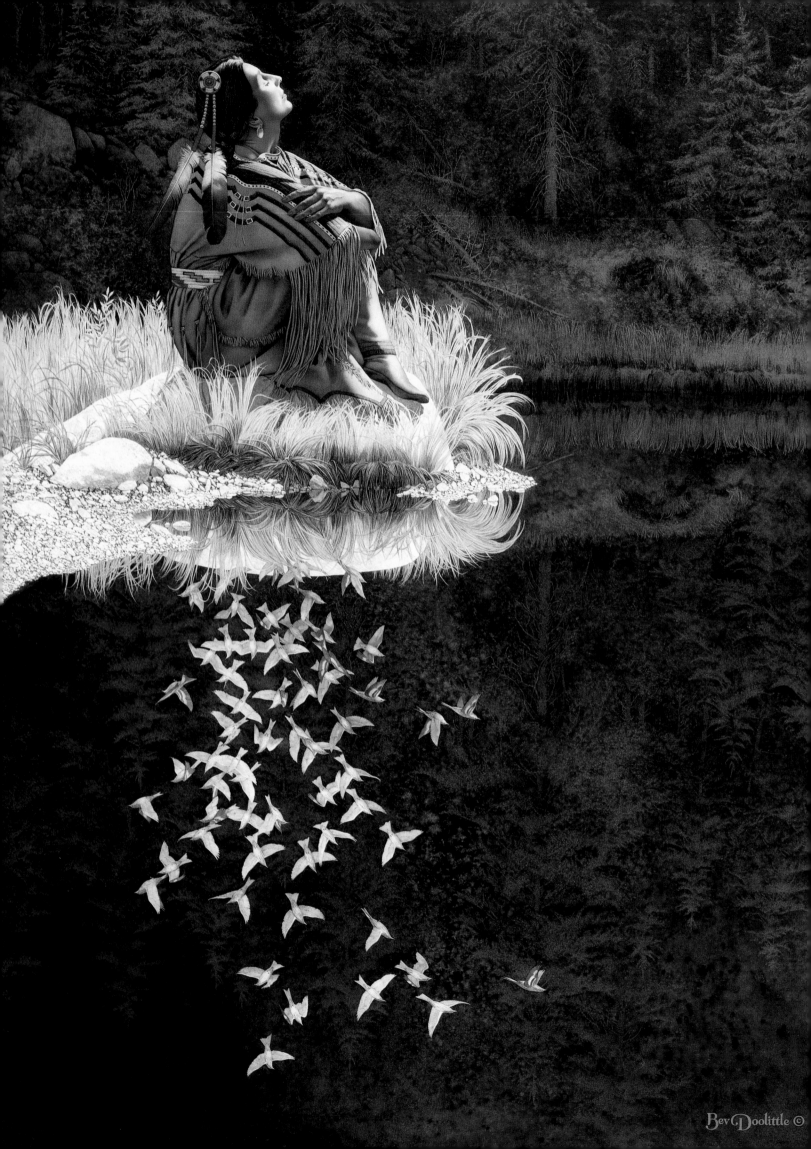

Bev Doolittle ©

Let My Spirit Soar

My thoughts fly up like birds in the sky.

I am free. I can fly.

I go everywhere. I see everything:

Towering mountain ranges

And a tiny flower growing in the desert.

I see cities and highways and a fallen tree.

I see a grandmother telling a story to a child.

I sit quietly

But my thoughts fly up like birds in the sky.

Only I know where they go.

When you sit quietly, where do *your* thoughts go?

What do *you* see?

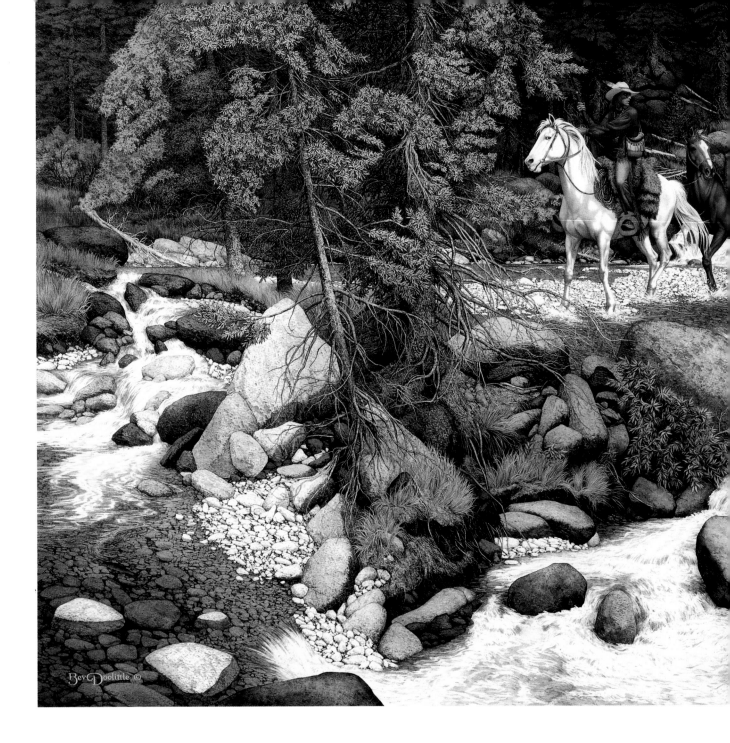

The Forest Has Eyes

They lived on this land and loved it

A thousand years before Columbus discovered it.

We call them Native Americans.

They called themselves The People.

They were scattered like leaves.

Where they walked softly, cities roar.

But their spirits remain.

We can never be alone.

Someone who loved this land

Watches over it.

Can you see the faces in the forest watching you?

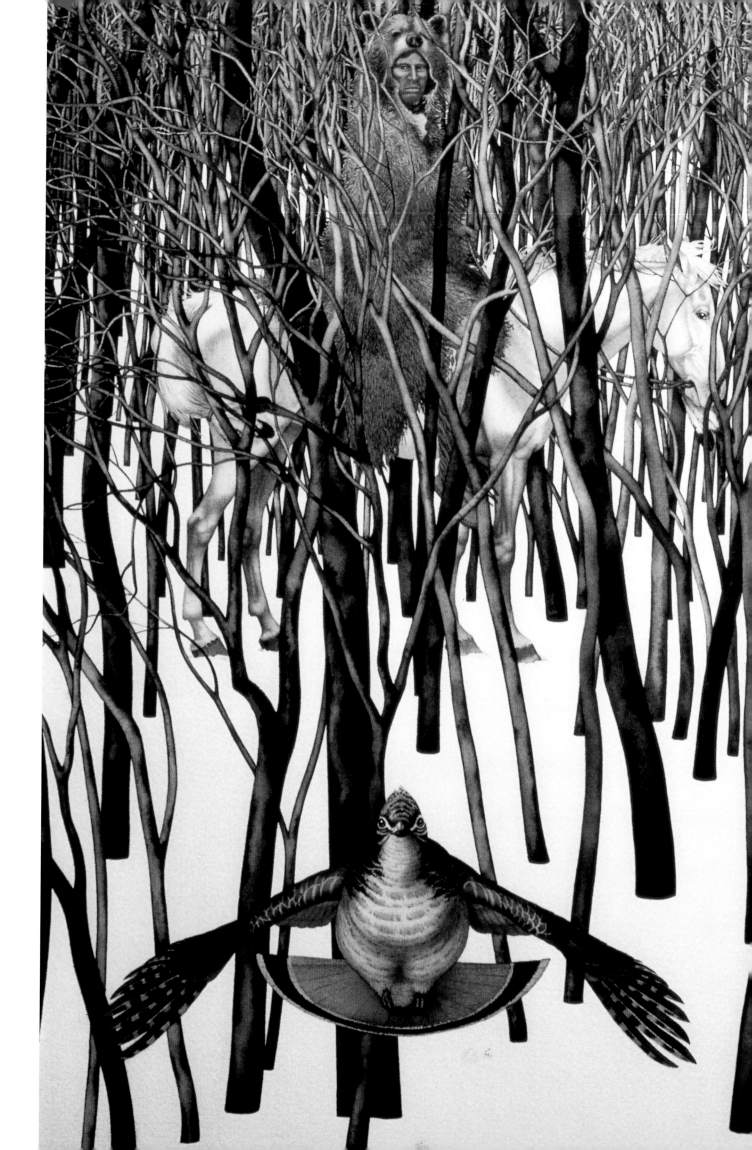

Surprise Encounter

Nothing moves.

But in a moment, the silence will be broken

By a brave little bird making a great commotion.

"Follow me! Follow!" her fluttering wings will say

As she flies up

Frantically flapping

Leading danger away

From her chicks in the nest.

Mothers know best!

What did this
ruffed grouse
mother see?

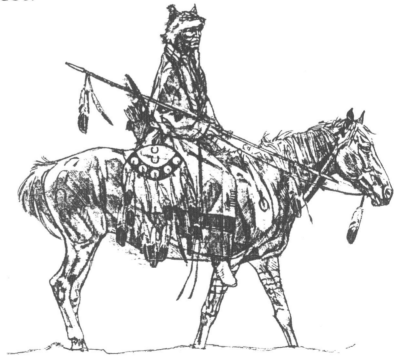

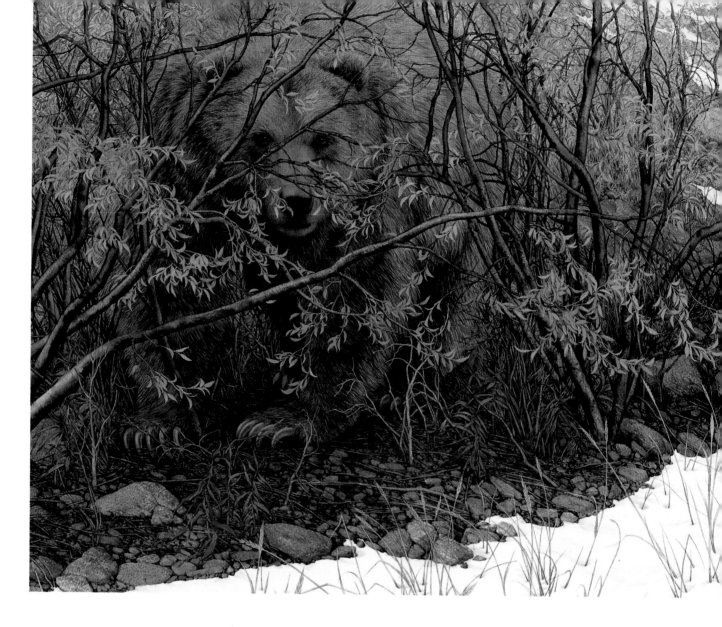

Doubled Back

The Munsee-Mahicans believed

That when the people were hungry

Grandfather Bear would come to a woman in a dream

And tell her his secret hiding place

So that the hunters could find and kill him

And the people could be fed.

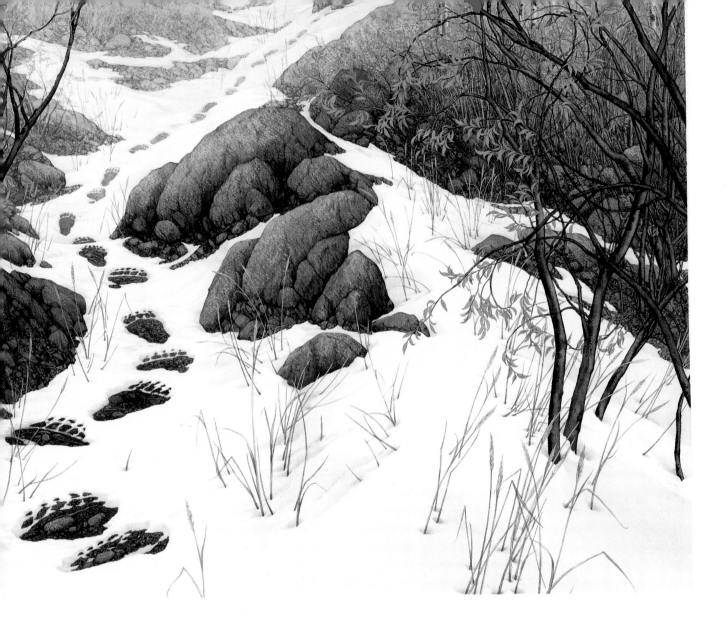

The people were careful to share the meat

To waste none

To make a warm robe out of the fur

And to carry a claw or a tooth

Smooth as a pearl

To remind them to help others

And to be grateful to Bear.

Can you find Grandfather Bear's hiding place?

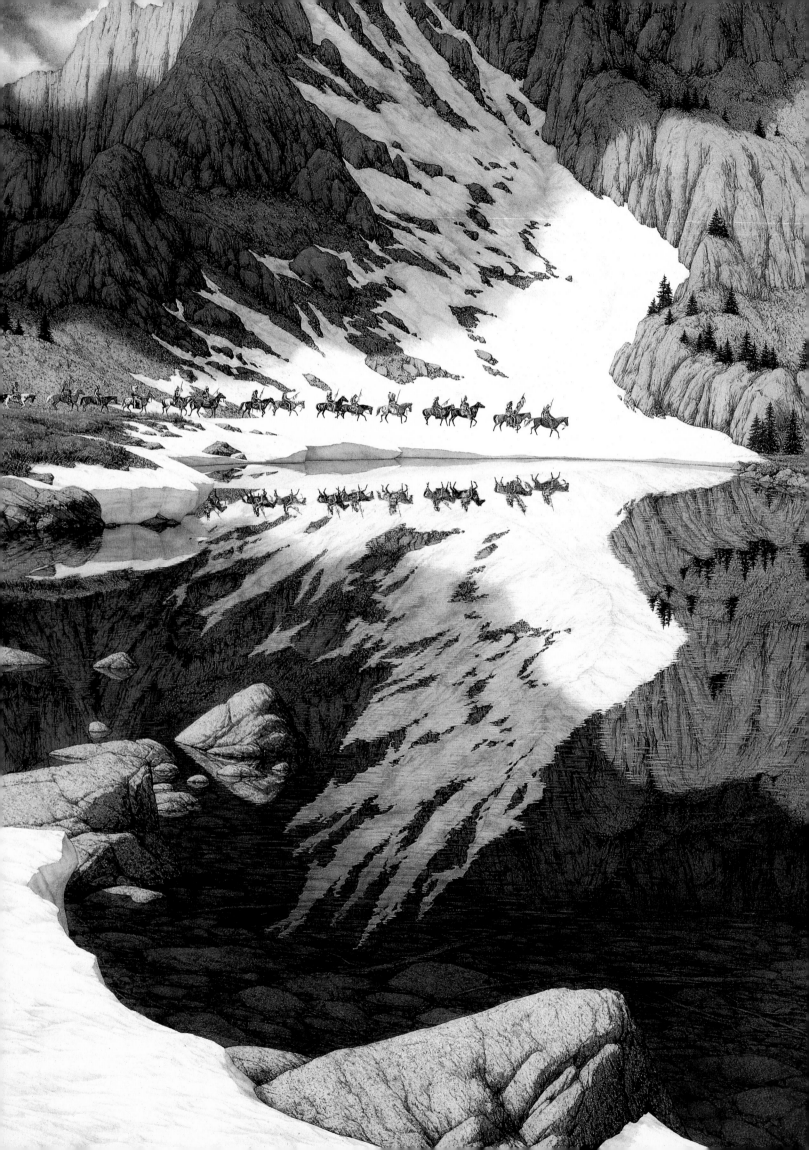

Season of the Eagle

It is early spring.

The people are getting ready to move to their
 summer home.

Fifteen scouts ride ahead to show the way,

To blaze a trail.

Day after day

Fifteen scouts ride together.

Day after day.

But suddenly one day when they ride beside

A crystal-clear lake

There seem to be more scouts riding with them.

How can this be?

How many scouts do *you* see?

And can you guess why the name of this
 place is Snow Eagle Pass?

Buffalo Brother

Hoka Hey!

Follow me.

The buffalo chief knows me.

I am his son.

When I call, he will come.

And the herd

 will follow.

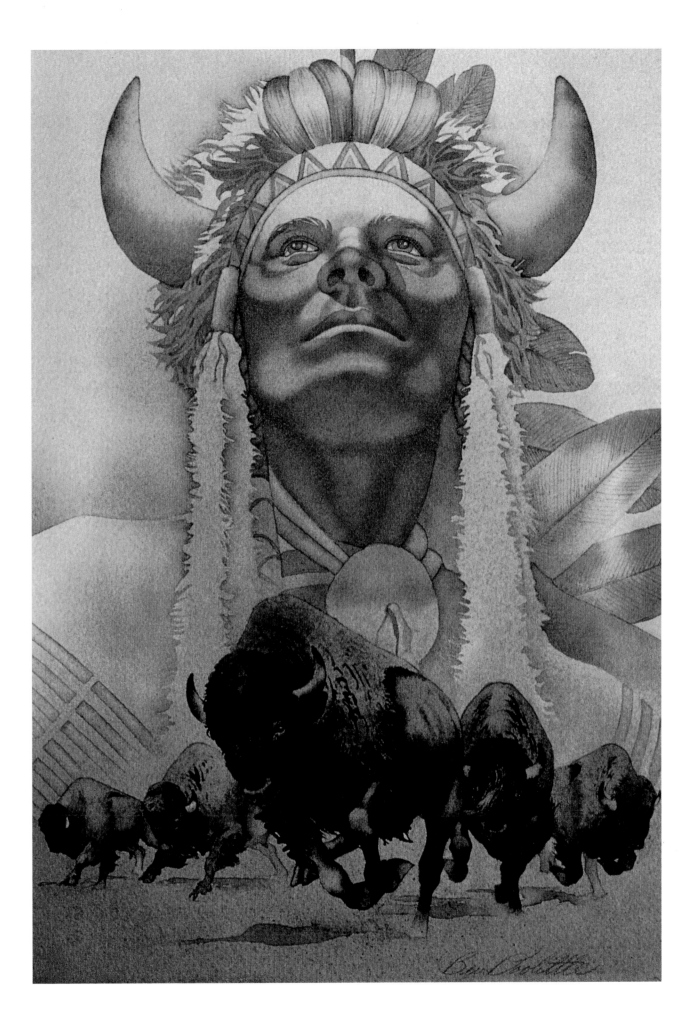

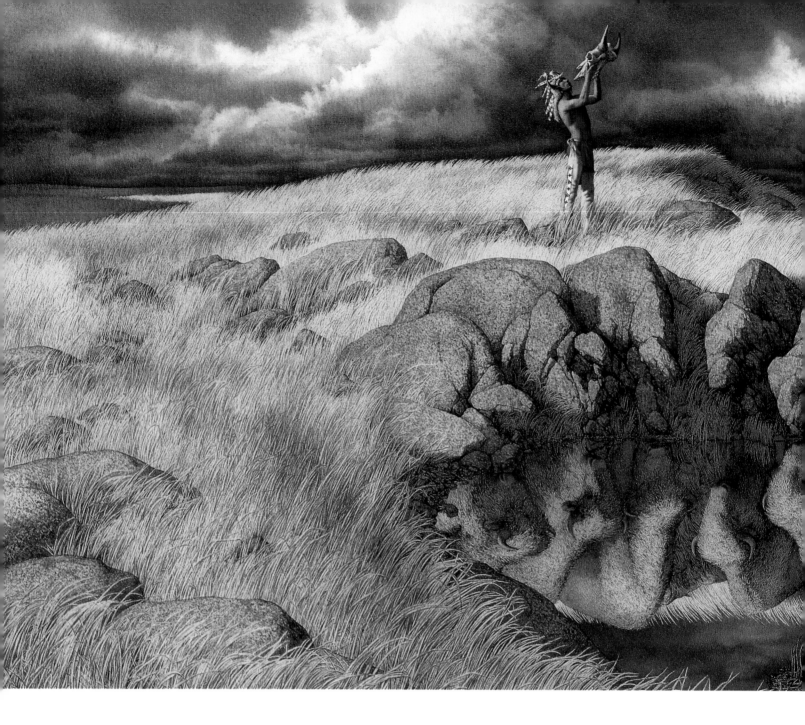

Calling the Buffalo

Hoka Hey!

Follow me.

I am calling the buffalo.

I know the sacred way

To sound the horn.

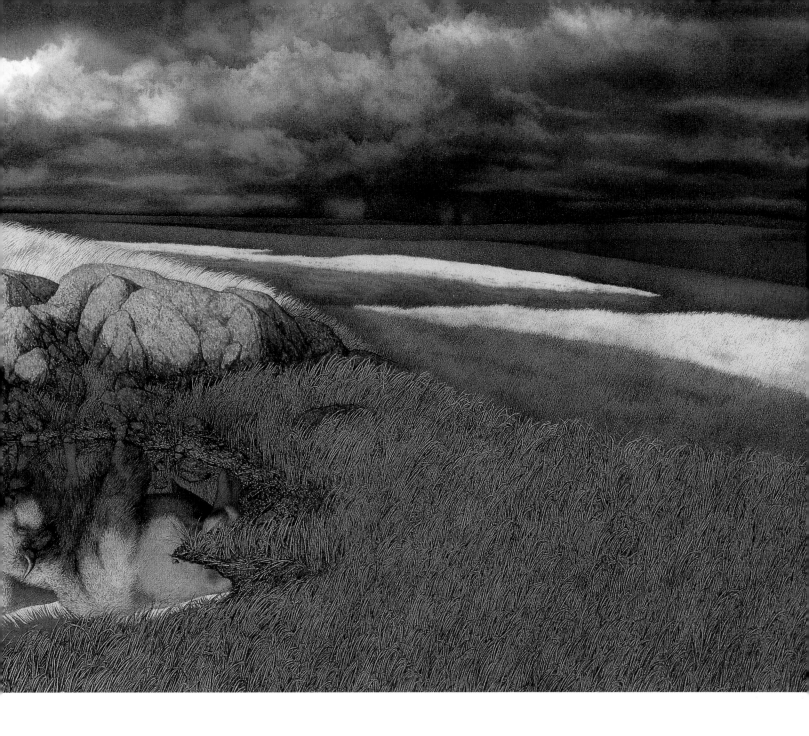

I know the secret words to say.

Tomorrow there will be

Meat for old and feeble people with no sons,

Food for women with little children and no man.

The buffalo hear. Their spirits are near. Can you find them?

Runs with Thunder

Hoka Hey!

Follow me.

The earth will shake

And the dust will make a cloud

But I will ride in close.

I am not afraid.

I am Runs with Thunder.

Tomorrow there will be dances
 of thanksgiving

And the tanning of skins.

And when the snow comes

There will be warm sleeping
 under buffalo robes.

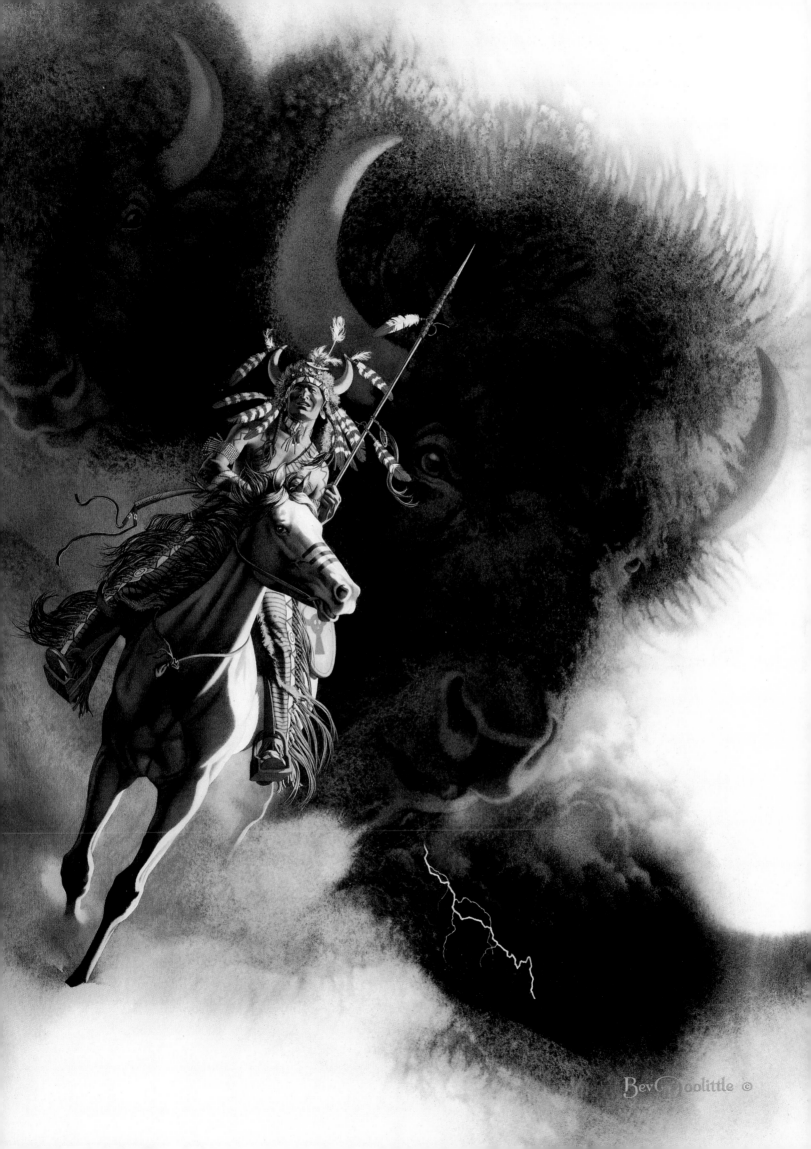

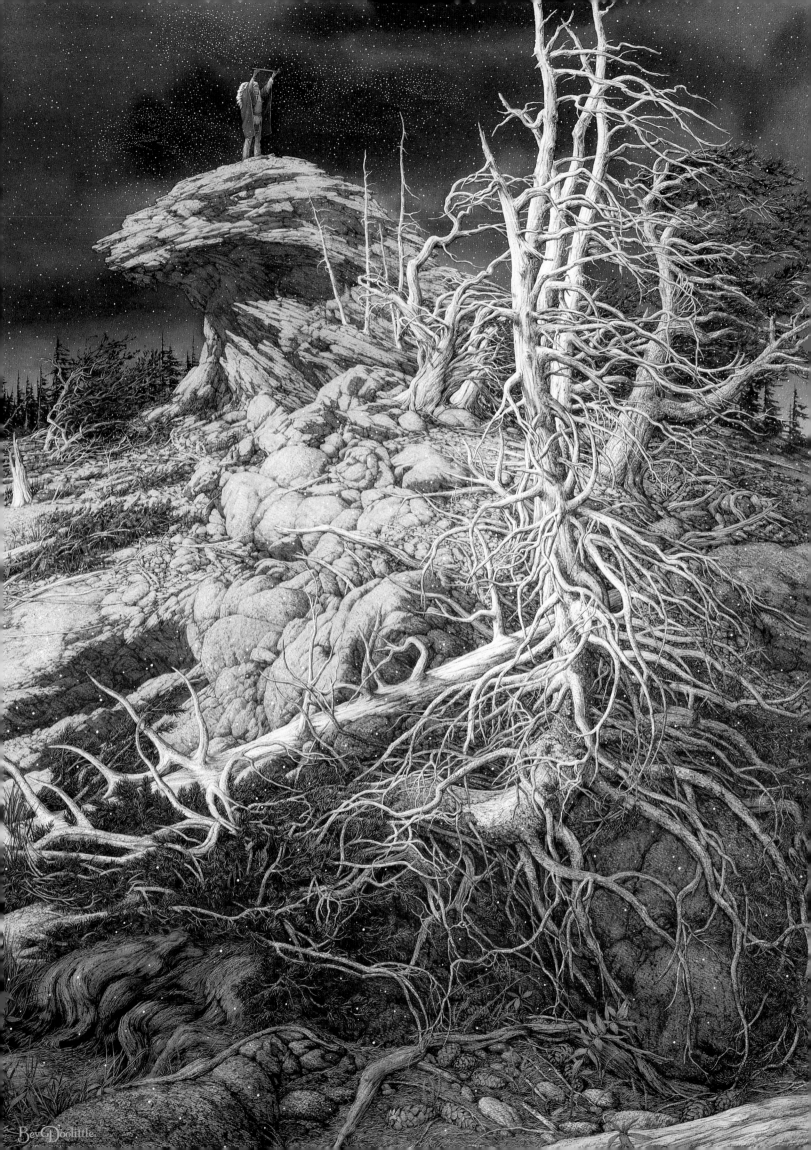

Prayer for the Wild Things

If you spend a long time in a wild place,

You hear things,

You see things you didn't know were there.

In this wild place

You might hear Chief Eagle Feather's prayer.

He is thanking the Great Spirit for the wild creatures

 that share his world with him.

The four-legged ones.

The ones that swim in the water.

The ones that fly

 through the air.

Hidden, but near,

The animals and birds

Pray with the chief

But not in words.

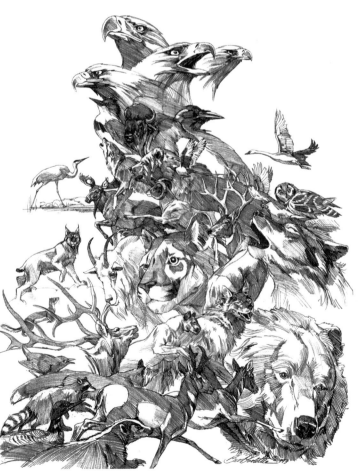

How many creatures

can you discover in

this wild place?

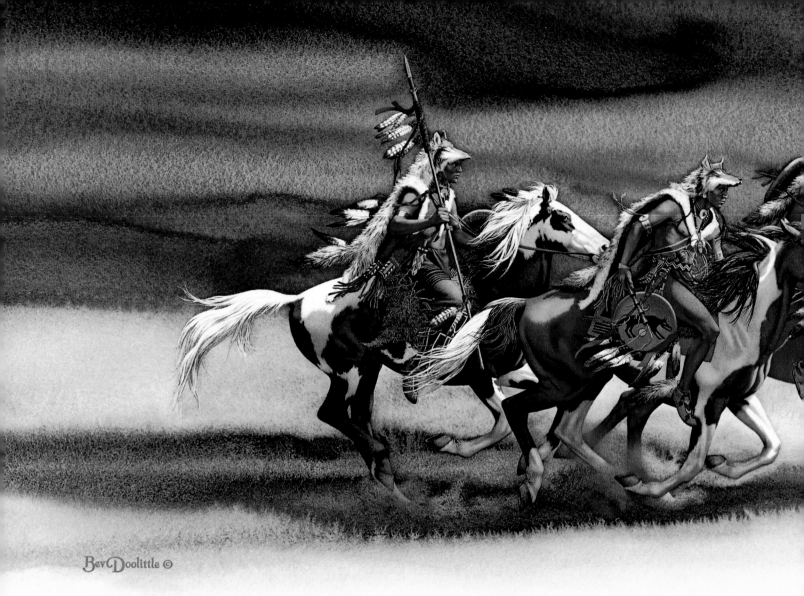

Bev Doolittle ©

Wolves of the Crow

Run with me, Wolf Brother,

Teach me to be like a wolf,

Faster than fear, stronger than cold.

To read the wind, to find the way.

Teach me to be as valuable to my tribe

As you are to yours.

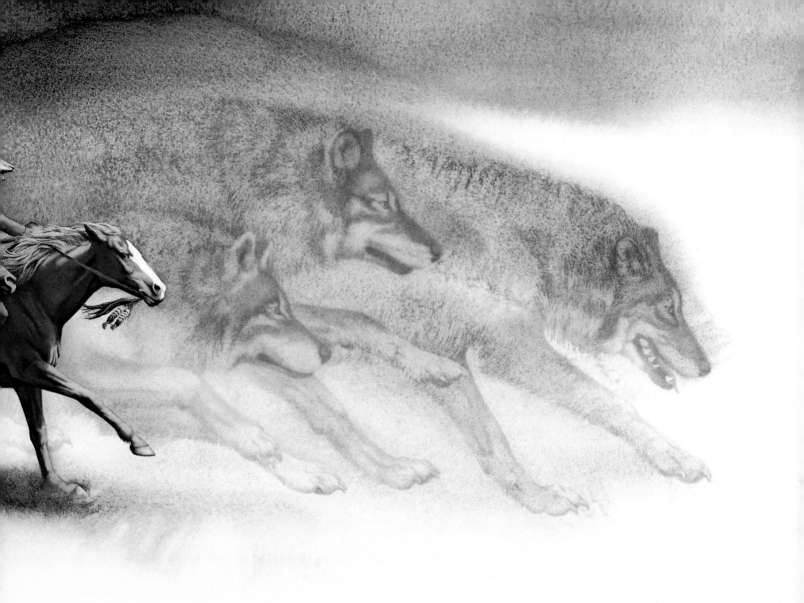

My people, the two-legged ones,

Have bulldozed your dens to make highways

 and supermarkets

But long ago, we ran together, spoke the same language.

If we can remember,

If we have the will,

Our spirits can be brothers still.

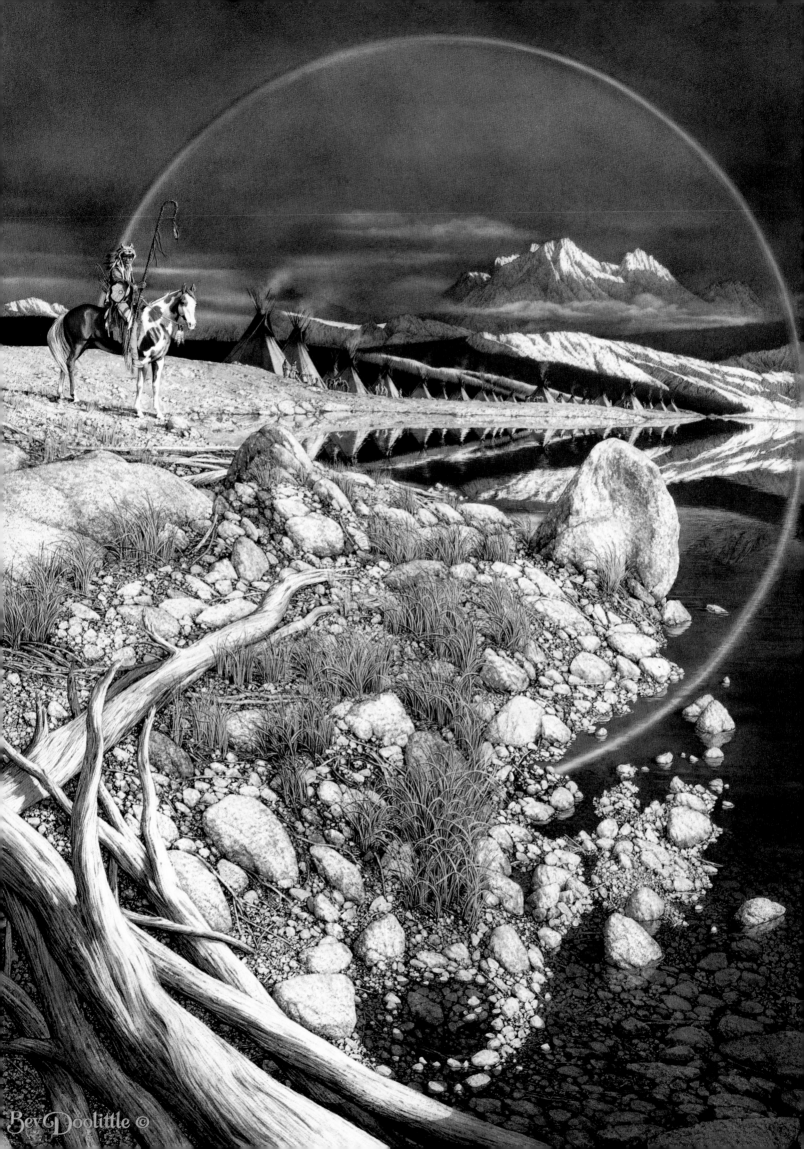

The Sentinel

Stay with me, Wolf Brother,

As I watch over my village.

Lend me your sharp eyes.

Help me to remember that I am part of all I see:

Every animal and bird

Every rock, every tree.

We are all part of the beautiful circle of life

Created by the Great Spirit.

Gray Wolf's guardian spirit is very near.

Can you see him?

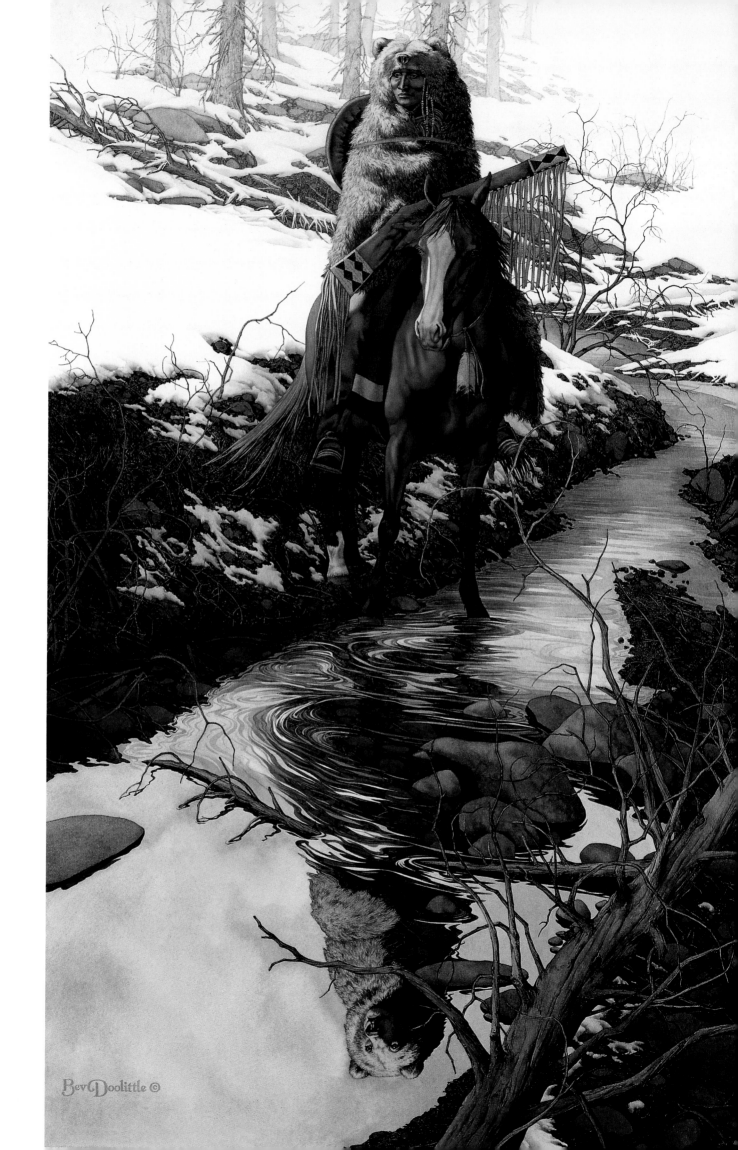

Spirit of the Grizzly

Out of mist rising

A young Indian comes riding,

Riding through bear country

Riding alone.

It is early spring, but there is snow on the ground

And a storm in the air.

The Indian wears a bearskin robe.

His name is Brave Bear.

Brave Bear has always tried to be like his name,

Strong, intelligent, brave.

He wishes that his guardian spirit could be

The grandfather of all bears,

The great grizzly.

Does Brave Bear
get his wish?

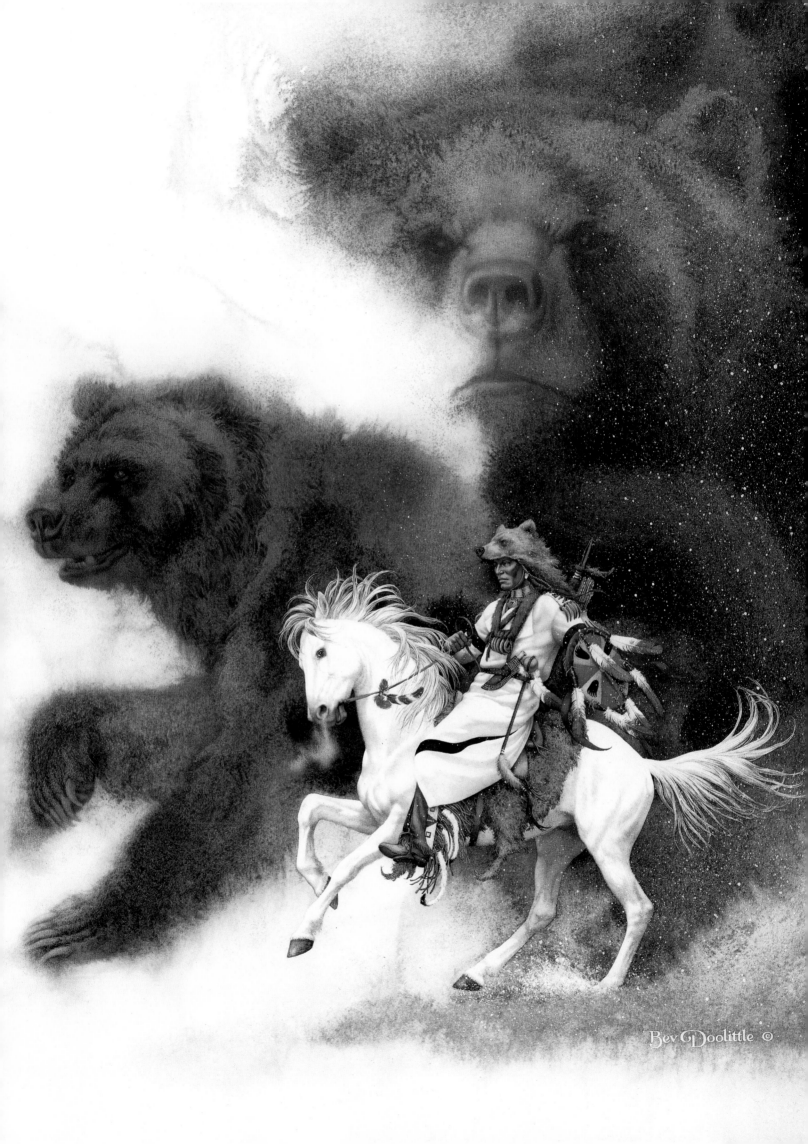

Bev Doolittle ©

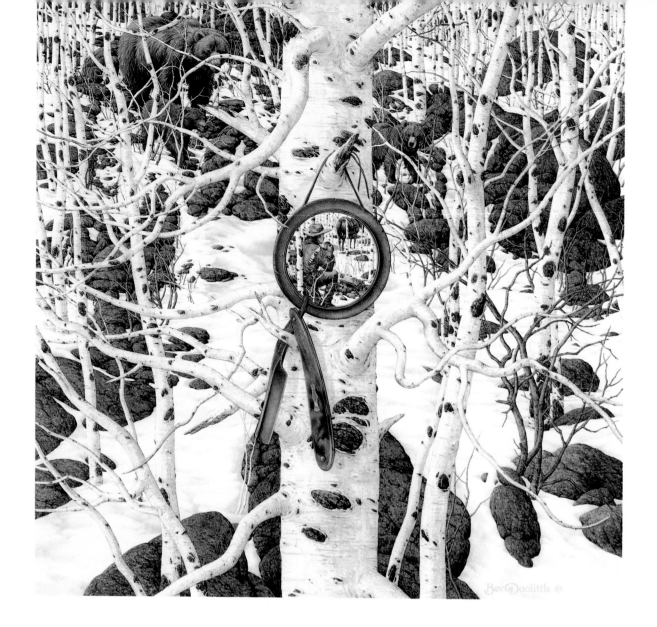

Three More for Breakfast

In the mirror he has hung on a tree

We can see a mountain man eating his breakfast.

He doesn't expect guests

But he is about to have company.

Who is coming?

He can't see.

But we can, can't we?